B ARBARIAN
S EASONS

David Blair

MADHAT PRESS
CHESHIRE, MASSACHUSETTS

MadHat Press
PO Box 422, Cheshire MA 01225

The Library of Congress has assigned
this edition a Control Number of
9781941196960

ISBN 978-1-941196-96-0 (paperback)

Cover design by Stephanie Grey featuring detail from
Donald Langosy's *The Feast of the Blind Fisherman*
Author photo by Christopher McKenzie
Book design by MadHat Press

www.MadHat-Press.com

For Sabrina

TABLE OF CONTENTS

A Drumlin Mansion in Ipswich 1
Black Mountain Music 4
For Sabrina at the Supermarket 5
For Goya's Public Ice Skaters of Spain 7
Is Writing Helpful? 8
Lines for Pope Francis in Cuba 9
Let's Not Think 10
Free Variation on Yehuda Amichai 12
Moony Nights 14
First Spring Days on the Basketball Court 17
Concord River and Walden Pond 19
Hairy Leg Poem 23
The Armies of Being Here to Eternity 26
At the Ends of Little Compton 27
Poetry of Friendship 29
Somebody Was Believable 31
Riding the Metro-North New Haven Line 32
Coffee Shops 34
Why I Love Some Friday Afternoons 36
Problems with the Early Times Poetry 38
By the Grave of Robert Creeley 39
A Waterfall in Vermont 41
Early July at Fogland Beach 43
Odd Facts about Cape Cod in Judgment Time 46
Sonnet for Older Fathers as Walter Matthau 50
At Fenway Park 51
On Jim Kealey's Ashes Launched with a Potato Gun 53
Thinking about the Bronx 55
For Sabrina by the Sound 59
Poem about Tony, with a Beach, Some Mountains, Five
 People, a Parkway, Some Jams, and Three Chairs 61

The Far Side of Election Days 64
Free Variation on "Wildwood Flower" 66
For the Friendship of Fanny and Ruth 68
For Dion in Belmont 70
Short Time 71
Big Family Poems 78

Notes 89
Acknowledgments 91
About the Author 93

When this yokel comes maundering,
Whetting his hacker,
I shall run before him,
Diffusing the civilest odors
Out of geraniums and unsmelled flowers.
It will check him.

> —Wallace Stevens,
> "The Plot Against the Giant"

A Drumlin Mansion in Ipswich

—for Stuart Dischell

If you want
to talk about mansions
on the hills, I am here
poking around the grounds
with a strange mansion,
with red-tailed hawks
shrieking high-pitched
and dive-bombing
each other
in a hawk fight—
up from the drumlin,
with the marsh to the west
and the ocean to the east,
beaches to the south.
The old mansion's rolling
green alleyway ends cliffside
where the Ipswich River
enters the ocean, the low
ocean striped for a long while
with sandbar tans.

The air snaps
like the spring
of a velvet-lined case,
eyeglasses in an oak desk.
The millionaire
plumber kings of Chicago
built this up, summer
imperialists. Their last

1

name on each piss pot
and jazz-age sink,
as if I tacked my shelves
with apartment poetry,
late and gilded
also intending
a line of myths,
some show time.

Each god
stands in a cellophane statue
tent against the off-season,
the reflecting pools dry
and the baroque bas-relief
detail heads getting lost
above the windows
in the pebbling wind.
The carriage road
winds up past
the rose gardens'
collapsing columns,
the cistern
broken with brown
moss cracks. I am holding
somebody's crystal
butane flute, too—
Article 1, Section 9,
Clause 8—cheers,
as if we knew. Taking
the higher perches
feels principled,

eccentric, stupid,
and national as ham.

Down the narrow beach,
the ocean cuts
standing stones
with the foam below
and smithy shells,
summers' bits.

Black Mountain Music

"The looseness of music,"
I start to say, but, uh, 10-4, negatory
on that comment. I stood ten feet
from a string quartet
and what I was feeling
about the violinist—so many
of these string sections
two elves and a big oaf
playing cello who looks like a cello—
my mind gone visiting Ben Shahns,
socialist realist oompah-loompahs,
the real short one named Nerdlia
from Romania, who stood
about five foot four
in her heels, big square
classical music heels,
I had to read all the program notes.

Tony Bennett says if he had done
nothing else but be a singing waiter
in Astoria, Queens,
he would have been all right,

just a singular voice.

For Sabrina at the Supermarket

I am here. You are here. Spring winter,
ten times the supermarkets in the snow
full of green crap
 for the holiday
that comes when parking lot snow
 gets old, even a display
of Irish Spring soap,
 and the manager's special stickers
gone on the corned blood
 around six p.m., Tuesday,
and other places I am
 glad we showed the Man with
 the Weird Beard
before he died,
his rare trip to Boston,
 that even my other mother saw
with her wizened skeptical genuine look,
leaving me to learn
 the grouchiness of the sages
boxed in with the wine bottles,
 the repurposed,
the everyday, the okay Fridays of Lent,
and then Easter, and the fifth of May,
 I hold that in one part of my mind
as if we were all
 Mt. Purgatory-shaped with carousels of fire
swirled around
 these knit hats in red hair and good
aggressive backtalk
 and love and pissed-off feelings,

the basic models for basic people
 we are not, our downslope
woods full of witch-hazels
 yellow and all their tongues
sideways out of their mouths,
 their flags, alack,
 their handkerchiefs.
You just fold your arms
 as if to say
 you can wander
around these stacks, fool.
 Moonlight in the trellis, the garden.
 The rosebush is going to fill out.

For Goya's Public Ice Skaters of Spain

Mostly nothing between my mind and poem, I do
not regard the wet night that dries
away from the house on the rubber roof,
dry snow always a misnomer
as it chases itself there into and out of drifts
until the snow sticks. The town rink
keeps full of fascinating cold
from the hard shine of its oval
to the brown wooden rafters,
to the metal stands, the penalty boxes,
scoreboard box, team benches, cinderblock
walls that do not screen out the cold
with dreaming goons and figure eights,
to ads for insurance agents and dental smiles
and restaurants. I do not sharpen my skates.
I don't care if they look dude-like or femme
and never did, was always a dork, a shmoo.
I go slow, I keep upright, I sweat and ice over
at the same time, outside night, outside daytime,
surrounded by miniature figure skaters, blue tops,
hockey pucks, hoodlum-loompahs, the middle-aged
and the old, and teenagers who also remember
the rinks other places, all of them outdoors
in the snowflakes, sudden stars, nobody talented.

Is Writing Helpful?

hellish bullshit ... men love it
men stupid as cows, pigs
—Ikkyu (Berg)

After telling each other
some awful stuff, the three of us
were poking along Houghton Street.

Then, wow, there were grapes
and a tan Cadillac sedan like a bubble
parked under a trellis, dim in darkness.

And we stood there in the dimness,
smoking cigarettes and enjoying
the jam smell, all September buzzed.

Then somebody got in that car,
turned on the lights,
drove away. Where to?

Lines for Pope Francis in Cuba

That scene in *The Leopard* when the family goes to mass
and sits up front alongside the altar in high-backed wood,

but now this—

 that nun who is young for a Cuban nun
in a brown habit like a cigar wrapper sings,

that big-band orchestra of cardinals in red beanies
about to stand up and swing that music behind the pope,

that country, we keep a jail there,
that damp closet, we like the sandwich,

that country that is so close and so far away
and is perhaps shaped a bit like kidneys or livers,

that old scholar who seems beyond grading people
and thinking he is some sort of big-time standard,

that space they made for the priests and nuns in wheelchairs,
that sense of hot, of tropical hot, and antique standing fans.

Let's Not Think

Let's not think
this is too much of a city.
Twice this week, driving
just before dusk
home to dinner,
I saw rabbits in the snow,
brown coats flecked
with white, one booking
from behind a snowbank,
the other by a pile of snow
contemplating the driveway.
These fast mugs always
keep looking for food.
And later, around ten,
every night
I go for a walk,
happy to think of rabbits.
I take what I have written
so far over to my daughter.
I cut it out as a rectangle.
I center it on a piece
of paper. I make
a quick sketch
of a sort of dense carpet
pattern of interlocked rabbits.
I want her to wallpaper
around this poem
with all these rabbits.
Maybe they can be
blue and green.
Xerox one, practice

some to get them right.
She looks at me
and says, no way, man.
I will fill the whole world
with my kind of conies,
some of them sharp-toothed,
long-clawed March hares.

Free Variation on Yehuda Amichai

After one joyous header
after another and chasing
the kids with seaweed
in a game called Sea Snot,
ugh, readers, must we
always be just bad readers
already in the crawl space,
who hotfoot sun pain
and think and think
to the wooden slats
through the dunes,
together and apart.
Though the sand cool
powders by sundown,
the sand still deep-fries
almost like cooking coals
under ashes, bone ache
still burning, the price
going in and going out.
Then the parking lot
also breaks me up,
all that hullabaloo
with big guts and butts
including my own
of families with crap
to tug and stow,
blacktop radiating
painfully and people
hotfoot there, sharp
asphalt granola shards,
except deceptively thin

teenage lifeguards
who must have thick
calluses, they walk
so naturally, one paw
in front of the other,
who eat dried cat food
and chow down cat pain.
These great Israeli poems
get into things like sand
in the black nylon seats
of a white compact car
again just from the ocean
and the sun and day
ending and being here.
Drive us home, stop
for ice cream, Norway
between the two girls
in the backseat, bored
five minutes in the car.
Their bellybuttons pop
out because the doctors
who delivered them
had to give them
a hard yank at birth,
that concentrated
esprit de corps child
sadness of evening
for anybody else
yet in a moment. Oh
God, this day, this day.

Moony Nights

1. *Buying Some Beer*

The problem with the country
is the Cleveland Cavaliers, the Yankees, and the Cubs—
all these insufferable stories, everywhere,
and people getting involved with the story
of a city without story or one with a story,
and you watch a ball game with the sound down
in a bar, and the players are all acting like babies,
muttering, scrunching up their eyes, moaning, hoping, believing
in the story, the real story that is them.
Sometimes, there is a kinesthetic genius
who has no story ever. It gives me hope.
I like the way people run on elliptical machines
and the way my mother and sisters in leotards
used to go prance around at Spa Lady after work.
There are some smart people who are unlike music,
but let's face it. They are not really all that smart.

Sweet felicity, what for twenty years
was I then? I felt basic, going home all
smiling, holding my six-pack for later
in my hand like a bowling ball bag
or an old-fashioned lunch pail,
the strap of the bag
heavy across my fingers,
going off to work
or the serious play
that I chose to stake my life on.
I did choose. Hey, dummy,
I have to say to myself,

stop being so literal.
Those are baseball players
and not cavemen carrying clubs.
Everybody is necessary.
You must be necessary for you.

2. Sadness

I remember you were the one there
standing by me, smiling with me.

Your cat, your dog, that pain,
sings, "Rescue me." Always.

When I walk by
the Armory castle,

I have to guard
the Armory castle.

The word *ugh*
gets to be a word, too.

The stuttering, happy breaths of a dreaming girl,
even a nine-year-old. Out in the sky,

someone sleeps, someone, someone sleeps.

Some beautiful person leaned out, rang
a bell out a window after making it creak,

 casting a spell
on the night and the neighborhood and you.
It wasn't a raccoon. She was opening a window.

First Spring Days on the Basketball Court

—for Alan Shapiro

The gracious Dominican high school ballplayers
show up on the court in their baseball pants
and shirts and start shooting around
and even though most of their shots
are off, they are moving the ball around,
looking for each other, looking to pass,
and even I can distribute the ball now,
and fifteen minutes later, I am not
having a heart attack or wheezing
but calmly sweating. Here's why:
they are not chumps. Chumps exhaust
everybody. I don't want to hang out
with five dudes like me, lumbering
and lunging choppers who move
constantly at the hoop and though
they stink at it, they are exasperating
and exhausting. My God, man, you
are such a chump and yet to squash
you I have to actually get in your face
over and over again. People who know
how to team up, they are devastating
though not using all of their energy
at once, and consequently, your defeat
or, yeah right, victory is not the horrible
grind of one on one, but a fluid
and efficient machinery of care. The trees
are budding or the sepals are about to open.
It's the same from April to June
on the court, in the green and golden

light of afternoon. The daffodils
start it all out, like the initial displays
of beautiful skin. You don't have
to put your sweater away. You can go
outside in a raggedy torn sweater
over your tee shirt, and wear shorts
held together with safety pins
and splattered with house paint—
house paint? You are such a chump.

Concord River and Walden Pond

Parents scramble the last week
before school starts up again
at the pond, *Parking Lots Full*—
come on back again at three
for transcendental parenting.
The heron was a big pale
hunt down on the bend
of the river. Then I got into a fight
with two new fourth graders
right on the bridge,
one of them Astrid.
The Minutemen stopped
the redcoats. Not a professor,
a man with a butterfly net
sang us "Concord Hymn."
This is one flaky state.
I was the one who needed
more sunblock, a pith
helmet. We made up
and got back to the pond
towels up on the wall.
Had to read Hopkins, bláh
bláh. I was being no fún,
going back to school, too.
There were damp teenagers
down the wall. Three kids,
two girls and a boy,
skinny suburbanites
with strange belly buttons.

Distraction can be
a good parent, maybe—
at least kids know
you have interests.
Everybody likes
to be the only one
with alibi jobs,
and the only other pleasure
contradicts that: company.
The shorter one,
the one with shorter hair,
liked his small-nipple self, too,
and so not getting the picture,
stroking both of them,
standing up
and actually pushing
her breasts together
to get the water out
of her bathing suit top.
Hardy was feeling
terrible, at least dactylic
taking the long view
and taking carriages
in his head as his wife
while I almost said,
"Kid, that's something
I never saw before.
Good luck."
Then Astrid ran
up and pounded
her water bottle.

Then Squeegee
took her camera
out with a ridiculous
telephoto lens
and started taking photos
of her two friends
eating grapes.
Fifteen-year-olds,
sixteen-year-olds,
my ten-year-old,
what goes on,
multiple idylls?

Then these two sun
raisin and strong
Concord ladies
with local accents
from lawnmowers
with deviated septum
came swimming
from the boaty middle
of the pond, way out
like Katherine Hepburn
swimming to Dover
from France,
the moms, my peers
who do things better,
who brought them here
every free summer
day since forever.
"You have *thirty minutes*

to do something."
"That is enough time
for us to walk around
the pond if we go fast."
Then the shoeless three
raced off for the woods.

Hairy Leg Poem

The logic
of sweat, cooling down
everyone who sweats,
starts to work
midmorning in an hour
of leaf-shaped lights
under trees and awnings,
the park benches
that rise along paths.
Now the sweat gets
idealistic awhile.
The small dogs
look confident,
umbrella stroller
kids and babes
in slings hanging
onto skin
like dew beads
or pollywogs eating moss.
People prepare to travel
with school out for some,
and a woman heads fast
for the train station
with her private kids
and rolling suitcases.

Not so millennial now
in a slow evaporation,
some guys look casual
with un-drying goop
in their prepared heads,

the summer with big
sundress shoulders,
pale freckles
and goose-pimpled
shaved calves
for timeless offices
of financial planning,
temps by other names
dressed for hard work.
It is a heat wave.
The Vandellas
got that part, hotter
all day, early evening
a blaze in an oven,
the intersection full
of the hake frying
and pig bones. Dinner
already. How could
that be? It's chicken.
It's dialectical chicken,
but maybe we get fish
with our washed-out
eyes for the bathtub.

It's sizzling out now.
See you in six hours,
starting to sweat.
Don't leave
in that white car,
that golf ball.
Don't go in there

to be continued
like my hairy leg.

The Armies of Being Here to Eternity

Maybe a college graduate or a student,
chunky clubby on hands and knees
squirts tasty bleach on the pedestals
of her exercise job purgatory
as if a boxer aimed his spit
at the gym floor
where Montgomery Clift
as Pvt. Robert E. Lee Prewitt
with spacy demented eyes
kept plucking dandelion violets
from the floors of physical health
where people bring their sad bodies,
and cell phones, and the half-employed
get their euphoria and their yas yas out.

At the Ends of Little Compton

Stones and zit craters
from stones
sunken with bicarbonate
of ocean and sand
like a vast pantoum
and a vast counter-sestina
all sounding variants, for sure.

Looking at the vacation trailers up on the rocks
opposite the end with the islands that look brown,

looking at an Irish flag
and an American flag above its scree,

I get the bald idea
for a novel about a ghost mother
in the first person,
in speech therapy.

She is just walking from dimension to dimension,
going through walls, heading up stairs.

The closeness to one child recedes
into the distance of another
who held her column of stardust.

We have to hear our father
watch cable news in the kitchen
in one of those things. Eating cereal.

On structures
with split shingle roofs
by the sea,
she hangs onto weather vanes
shaped like whales.

She can now enunciate the words,
Well, he's still a pain in my ass.

Then part of a broken clamshell, the hinge, seems to contain
a room or a seat for another clamshell.

Poetry of Friendship

Tom Yuill and I were dressed
in our blue blazer camouflage,
but I was wearing grey pants
and he was wearing a pink dress shirt
in honor of preppie acid heads
from the swim team in Dallas.
We were running late for work
so got a cab over by the city hall,
one of those red ones with a top hat
and cane on the side door,
some town that jacks you on fares,
Brookline cab, not a green Shamrock.
The driver liked Pushkin and all-talk
and probably liked *Boris Godunov*
and since we were talking about Schwab,
our 401s, our portfolios, the bread,
he figured we were stone Republicans.
"No, man," Tom said. "We're professors.
We're trained critical thinkers.
We can't do that shit."
This got the driver c r a z y.
"What do you mean?
What do you mean?
What do you mean?"
His pupils turned blood yellow.
His tongue flickered in the air.
"You mean you are *brainwashed!*"
"No, man, we know how to think
and read between the lines of texts.
Look, we know where information
comes from and what it looks like. Period."

Then the driver popped his head off
with his two hands and a jet of steam
shot out of his neck. It was just awful
when he started snapping at the steam
and chomping at his shoulders.
"What do you know? I lived
under Communism. Fools.
You are professor fools."
We were at a red light,
nothing left but a pair of legs
on the front seat and a head
coughing in the leaves, coffee cup lids
and receipts, some of those beads
on the loose up there with a radio,
the jaws stuck on a steering wheel lock
which was like a big nasty tuning fork.
Luckily, we were near the hospitals,
so we could get another cab,
or it was close enough to walk.
There was nothing left to tip,
but I swiped my card,
punched in plenty
to apologize for brains,
stupid ones, crazy ones,
mean ones, smart ones,
all except the kind parts.

Somebody Was Believable

Somebody was believable, Olive Oyl. At the farmer's market,
so many arms with permanent tattoo schmutz on them,
part of me will always think, out-of-tune and step.

Riding the Metro-North New Haven Line

The question is what kind of sausage are they—
don't know, a lot of white guys,
some Weißwurst, Wisconsin brats,
Kelly's linked sausage, Ballpark
Franks, Oscar Meyers, the Wharton
School, Bob Evans' maple, vegan—
some flavor businessmen mainly,
at the bar that has spilled
outside Grand Central Station,
the sausage are in pinstripes
and swing martinis, weights, glasses
of beer, some wine, who actually
give each other clearance
of half an arm length
to avoid bopping each other
in the noses in mid-brag
before riding on back
to Cos Cob, Darien, Westport,
or up along the Hudson
to Hastings-on-Hudson,
the train full of brilliant light
now that overcoats are gone,
and there might be a hunkered-
down old capitalist in seersucker,
face red from the trip to town
with a boating complexion
or maybe just drop-dead pink
operating how well it is hard
to say of him or of anybody
as if there were firmament
above the firmament.

I'm this pulmonologist
or I can pry my cabin window
open and see the wavelets
and the white wine effects.
There is a voluble group
of ladies who are drunk
after work talking about
how much better it is to be
at Revlon rather than B.P.,
laughing snorting yukking it
up, business ladies; we know
what they would sound like
if they were collaborators
in Vichy France and Germany
had won the war. The same way.
I think I know how a jerk thinks.
He walks along lower Manhattan,
down off Houston Street
and when some oldsters
are out in sunny lawn chairs
alongside subsidized old-age homes
which are hard to get into,
those freeloading bums
still with the good location.
Everything else is too far away.

Coffee Shops

Under so many
tables enormous white
labs with pink noses
flop against dining room
legs and call the whole
consignment of a parlor
set into question,
swat of a big tail
against a cabinet door
causing the stacked boxes
of herbal teas to tumble.
A breath comes
down the street
under the small white flowers
of the locust trees
that drop like parachutes
held down by rubbery sepals.
The pinwheels spin
in the gardens,
odd choices. All the mess
downstairs gets piled
out on the spare bed
to make room
for a party. While baristas
fuss with the credit-card
machine and put
the dupes in the right
places behind the bar,
she has been dotted
with dark freckles
and moles like drips

of chocolate, cold
press of nose ring
piercing everybody
who happens to be.
The mint seeps out
of the stone-ground
sample in our mouths,
small blood flecks
of sweat pimples.
Rush, rush, rush.

Why I Love Some Friday Afternoons

Needs paint, warped wooden fence city
and March light seem to blow
beer smells that rain leaves
in traces of lunchbox milk
spills in the girls' hair, backyard,
trotting past me, pretzel-eaters
as they dig up broken plates
and crushed drainage gravel
to get down to the real dirt
pulled up under patio brick.

All week long, my grown business
consists mainly of my arms
swinging along, pounding
the sidewalks to and carpets in
buildings, the weird tiles,
horrible elevators, tin cans.

All these grades only come
around once. No freedom.
Something has to slide.
There is some mentality
happening upstairs
that matters less to me
than two-tone tasseled loafers.

Now because these two kids
goof here with their spades
scraping around
and making big plans,
basketballs rattle and plop

on the court across the street,
to birds in backyard trees
and gutters, and the pale
vinyl colors on houses
right before small rain
can rain down big drops.

The brown eggshell lift
variegates different skies
that suddenly look like dirt.
We need some goats here.

Problems with the Early Times Poetry

Out with yard stars and the ragged tomatoes in coffins,
the big houses and the grills throw smoke. Eat the whole
grill, why don't you? Big country. We all loved younger
poets. Let me tell you of the early days when the settlers
lived in these log cabins and did nothing but make Alpo.
They were writing folksy love poems. They were smearing
Chia Pet seed all over the terra-cotta sculptures of Yoda.
They missed the path through the dunes and wound up
in the dunes with some biting brown flies and then pricked
by cactuses and dune grass with secretive sawtooth edges.
They filled housefuls with heads in the rain, piling creative
anachronism shields and swords made from black foam
wrapped in silver duct tape. Their beards and their armpits
smelled like green lentils cooked with smoked ham hocks.
There were hordes, and they lived cheap, but they slept late.

By the Grave of Robert Creeley

Look, here comes everybody
poking along up and down
by Indian summer accident
that makes the daytrip go along
forever. Then we have a map
and might as well
find Creeley, up one street
named Mound Avenue, weird, what
next? Bone Yard Boulevard,
and then one that wraps over
and then beneath an embankment
with chipmunk rhododendrons,
and an intersection
dominated by the scaliest
locust tree bark
with the horniest branches
ever, fine on a fall day, not
in the dark or fog though,
gradually seeping in
the disused and sloughed off
coils of New England names
around gothic fencing
and many an Ezekiel,
an Ezra, in Mount Auburn,
and finally Creeley's grave
mossed up twelve years old
and already the oldest thing
with lines I won't even quote, so
good, on its backside with the prospect
of the day he meant us
to see, the family nearby

from the age of sea captains
and starch, strangers to him
in the woodlot wilderness, best
term for every woods
between roads, part
of initiating strangeness.
How to be a person
making mistakes,
that is the question, with ground
hairy beechnut shell
and sepal strewn, branches
down, odd segments.
Sabrina decides to stretch out
on her side in leaves
with head up
on crooked arm. What is she doing
down there? Has the smithy poet's
capacity to charm
outlived his body?
Astrid pranks up leaves
in a circle of girl feet
and alternates her dial
between cheek and spook,
the ground charged with goat
and bad chemicals for grass
at our heads and light hearts.

A Waterfall in Vermont

beautiful

Around the cairn in the water
around the bend from the falls,

a palsied man walks and moves his mouth
while his shoulder twitches
and the fingers of his downward open hand
trail the water.

Two girls dive with goggles
into a deep spot—
the first one
shouts the other
away from submerged rocks.

Some art students or club kids
at ease direct their cameras
at each other, thin
and healthy on a ledge
of their own green mountain.

They take turns keeping the gear dry
and take turns wading.

On the banks across the water,
two thin apostles of being pale
with long brown beards
pass a nude toddler back and forth
while a woman breastfeeds her bare baby.

They remind me of pistachios.
They stab out cigarette butts.

41

A summer with a lot of rain
and a new baby
keeps them indoors.
The wind makes the pale sides
of the leaves turn up.

Then just the sounds of the falls
and the river
and rain falls,
muffled voices
of people in trees,
of people afterwards.

Early July at Fogland Beach

All fog tastes like flat Moxie
in cloudless July heat,
but the fog rolls later on,
more and more of it
as the months turn,
white-enveloping
the coal plant drums
up the Sakonnet River.
But on the marsh side
that hot bright day
down a sand road
through high weeds
edging to spartina
from the parking lot
to pickup trucks,
we met some people
been here for years—
fishers, quahoggers,
beer can drinkers,
smokers under tents
in the tar-and-coco smell
of water, gaunt eyes, no
music, no sports, no
target shooting, no salad
dressing, no wasabi peas,
no battlefield earthworks
worth trouble, no beagles,
no ticks, no blood clots,
no grilled chicken breast
in warm mayo, no lettuce,
no politics, no shittiness.

Our feet on the stones
and broken whelk shells
with bone curves
like amphora necks
or wine bottle necks,
the low-tide mud a gleam
of pearled, black snails
the size of the marbles
you would not miss
if you lost them
and you went home
with a lighter leather sack
also containing sea glass,
inexplicably, a poker chip,
a white one, red clay
in its scallop grooves.
There was a jellyfish
in the faded sand pail
from kids with a net
like a thought bubble
the size of maybe a coin.
Look, kid. A hermit crab.
The earthy swallows
flew down from the hill
away from our names,
as we grilled and steamed
ourselves on the stony margin
hibachi. Past banked maples,
a pasture climbed
towards apple trees
and a barn

with wheels of hay
bigger than truck wheels.
Identify with egrets, too,
and their long, calm beaks
if things really seem jaggy
and clear on these banks
because maybe they get
odder and odder and older.

Odd Facts of Cape Cod in Judgment Time

"their first political act: theft"
—Alan Dugan

Scrub pine forest
where I hope we do not
get ticks
with 15,000-year-old freshwater ponds
sand-bottomed,
and woods where your foot
pokes through
black crust soil
to sand, Massachusetts
weirdness, I love it.
I am like that dog
who stares all day
into the dinghy with no bottom
because it is a television
for fish or a water bowl
or a television for fish
and a water bowl, bonus.
I don't even know
one camper from another,
whacked bivouac
in a go-to-hell time,
go-to-hell time
for everybody, especially
around the lighthouse
by the tennis club.

Birdie's tough,
Sabrina says. *She can handle it.*

And then. *Looks
beat-up now, but
the house is well made.*
We don't know
the Greek Revival
columns at night
would be lemon and lime pops
in the morning sun, one dude
with dreadlocks
and beard has been
going here since
his grandfather was born,
unhappy whiskey
look around his eyes,
like a first Friday
someplace socially awful,
and the tennis blush
and clothes hang a certain
way on the boney-butted
frames of the blondes
and greying men
around whose sleep
seals blow yap-sized
bubbles that explode
around their tabby-print
sportier patterns
when seals are real
for shark food,
flippers like hands
and feet but not legs
or arms, but

47

who the hell
is Birdie, Sabrina?
I just made that up. You see
what happens when we
really watch. End up
gaping at Brett Kavanaugh's wife
in her struggle to keep lips
from staying open;
retrofitted, social X-rays
behind him in committee
because the plastic surgeon
gave one too many cranks
to the gears of the machine.
Then towns fill with fog
and cellphones in fog
and people in sweatshirts
that say Chatham
because they are on it.

Throwbacks, the reality
strays from appearance.
Hyannis, for instance,
actually gets located
on Waze and better apps
in southeastern Ohio, the horns
of the ferries
piped in. Let's pretend
we are near the beach,
and the tennis club
seems run
by the kids from Scooby-Doo,

even that scowling scion
with rasta curls
looking at the social contract
to stay thin man-boys
and bone ladies. I meet
a guy on the morning beach.
Great to be up here from Norfolk
where it is hot as hail down there now.

Sonnet for Older Fathers as Walter Matthau

I went to some parties that didn't work, and other
places our heads go, fields named for bankers, hard
cracked infield dirt, no rakes. The tennis courts
lit up at night, and we drove by exciting night tennis
in the city. We were encased in white polyester
baseball pants. The shirts were awful orange.
Who gets to be the fat catcher? Me. Sometimes,
a family tyrant sucked all the world into an angry
orange balloon. We loved dumb movies because
they got us. Somebody had to get us. I remember
a drinker with a pool who cursed and scared us
all. And our parents could be grouches but never
brought us to that bug-zapper, bad suburban place
again, and never just said anyone was that plain nuts.

At Fenway Park

—for Stephen Dobyns

Go, summertime. Worst one for me,
and maybe my punishment in Purgatory

would be so infernally hot
and coded with new money and ancient

histories of exploitation and control
that somehow sprout skyscrapers

like rabbits and deer heads raising
ears up in high grasses the colors

of their coats in the late afternoon light,
and I am pushing at the handles

of a desperate three-wheel tourist
rickshaw on wheels for the dock

with the last ocean liner in the world.
Ever notice how many people in the seats

around home plate at Fenway Park
in Boston smell beefy when they get

up to sing and stretch between late
innings, and the announcer does not

say that the following is a paid public
display of affection for kid soldiers

with taxi-door ears, and gobs
of tartar sauce on stretch pants

from all that fried seafood
and the ricotta-stuffed pastry

shaped like lobster claws. In some
other dimension, the faithful

tumble down empty dark tunnels
of poured concrete at game's end

holding giant half-empty plastic
cups of beer, and there are not

a lot of them, and certainly
they live in the enormous sheds

gathered around coal mines
and steel mills, pointing mouths

up to the heavens, not really
booing, but making a sound

that sounds like it, *whooooo-
oooooooooooooooooooooooo?*

On Jim Kealey's Ashes Launched with Potato Gun

The beach train crosses over an edge
of Salem Harbor, as a kid in a wet blanket
sarong comes through the door
that gives a noisy slide when kicked
followed by a wet lank-haired girl
in tie-dyed damp beach dress,
unsexy, friends, pasty, few-freckled,
the one who would have loved them
swirling around and going around.
Loaded his ashes into a potato gun
and fired him from motor boats
off Misery Island into the harbor
so his gravelly bits of crushed
and burnt bones could sink
to the channel floor and drift
on the waters to be picked up
and dropped by fish lips the way
fish do at the bottom of aquariums
and to be swallowed and dropped
grains of tooth and femur at a time
out to sea and down the coast,
to be sand down wherever fish go,
to Revere to Gloucester to the Cape
and on to Maine or the Caribbean,
wherever smokers gather on rocks
at the ends of beach, and the living
still with our earth bodies will grouse
at kids and look in horror at hairy
backs and bald dads and see perky
flat breasts and Dover hovercrafts
held back, and some of him will float

into marshes, even the ones on the edge
of the city, where Canada geese float
plopped down from marsh grass
by a shovel truck still by a big gouge
with their racing stripe white cheeks,
and to each other, oaky and dried
while the sky makes long thin
blue ovals on top of brown water,
and some of it, fine by him any day.

Thinking About the Bronx

holy Bronx
　　　　　—Allen Ginsberg

Even this Galleria Mall
bland, January calm,
winter comes in
flat as paint drying,
good paint, the fountains
in fake forestry cover
burbling, round pennies
on square tiles
in the basins, the whole
of the non-city freeze
shimmers on down
through skylights.
Even the rain taught
a lot of headspace,
and that is valuable
being on a subway
and next to you
people interested
in their own heads
as you were in yours,
hard and also like
a giant quilled pillow
pulled from Mayor Koch
or other giant bald guy.
Some kid who wanders
through the D trains
in a private strobe light
under the Concourse

decades ago changes
the space around him
by being that amped
in electric urine
and Poe Cottage.

Was that the young
Donald Revell? Maybe
empanada grease
and rooftop pigeons
breaking over
kids throwing rocks
far from Sarajevo
at bottles on a glacier
rock in the lease lot,
the fence top barbed
with backup mirrors,
fiery sunset behind
red Alexander's sign,
the old man calling
you Papi, one hand
on the ice walker,
the other on his roach,
then grabbing hands,
old long finger horns
not letting go
until he inhaled
with a whoosh, you
funky ass upstate hick.
People who have
been really alone

have their charge.
Whatever comes
off their wires
goes into your wires,
who swayed between
cars you felt them
going from side
to side and never
stopped going
from side to side.

The whole world
changes, but I now
think how something
does not change at all.
The way people leave
bikes chained in front
of restaurants all night,
how amazing. And
the colors of the bikes
too. A toothpaste-
colored ten-speed
city bike just leans
there with its wheels
still on it. How could
that be stable? It is
though, from that thing
that causes balance,
the inner ear, scrub
with no winter coat
pulling your pants up

darting to the market
which seems reasonable,
I mean real, concentrated,
face not bleedy, still okay.

For Sabrina by the Sound

High grasses with reflective
combs glow roadside, landscape
of disasters. I am not sure
who narrates and who fuses.
People she knew were private,
the rich kids drugged
with eighties money, by water
depending on what kind of boat.
Penned fields all but unhorsed,
basement suicides, kids smoking
around police tape, bedrooms
of concussed sleepers. The lady
who stuck her abusive cop husband
with a crossbow into stuffed cushions
lived right there. Big
cul-de-sac traumas, more kicks
around spooky Durham, the Klan
about to march on town greens
with their hoods, pointed houses
and churches, Victorian
additions to farmhouses,
hills stretching in a prospect,
and one brown horse blanket,
cattails, PVC pipes, truck ruts
past sheds, and a profile
cow, sudden, on a hillcrest
making a futile stand with a silo.
Leaving part of our minds there
wherever that was if we grew
up there after all, Hammonasset
feels impossibly mournful.

Late day on the beach pockets
itself orange in blue shadows
and dog paw prints, oyster shells
worn thin and cracked
empty but still hinged
together, slipper shells
stuck together to form
handles to partially
visible tools, presence
nondramatic as a seal head,
floating drift, rounded brown,
the rest invisible, not even there.

Poem about Tony, with a Beach, Some Mountains, Five People, a Parkway, Some Jams, and Three Chairs

Those spirit flying goggles
Tony was looking through,
even had a horizon in the end

with cloud-colored ships
and sailboat sails,
but were not a Thermos

and the gouache of squashed
pastel horizon leaves
and an Adirondack

with a black cashmere coat,
but a late lifeguard stand
when the water was blue

and the sun sliced mango,
papaya, kiwi and pineapples
into slices with shadows

on the after-work
bathers, the Brazilian
family poem whose mom

leans with small flash
of navel ring and small
bikini bottom, almost

invisible in afternoon print
sand top with bored kids
and grandma, but running

the show with finite,
finely tuned severity
to be heard sure as shit

canso, Italian-faced
man playing wild
islander with heavy-

metal grey hair
and ballooning jams
down past his knee waves

seemingly decorated
like a handball mural
on the Henry Hudson

Parkway in uncut sun
and the breeze ruffles
hair but not seaweed,

and he too sun worships
and already in the water
yells out to his lady friend

as she un-pops sandy
plaid vinyl grained
folding chair where she

said she would be, I guess.
What is this day again,
last Tuesday? She goes

out into the water
and they belly hug
each other in the tame

water that will never
be warmer than now
and has not been

warmer since last September.

The Far Side of Election Days

—for Gary Larson

When the great senator goes from state
to state, she gets even more amazing
the way Theodore Roosevelt was amazing,
I say. Then this little asshole I can
really imagine because I know
him goes, uh, she kind of looks
like Theodore Roosevelt, there, pal,
with those glasses up on her nose
and her hand in the air in a way
he might have taken to himself
in Bull Moose days long gone.
I know. You can't believe these guys,
these guys, you can't believe these guys.
We are talking about places in Wisconsin,
and Illinois, and Michigan, and Ohio,
big states, delegate-rich territory. To apes,
it's like she comes to life right out
of a cartoon that hangs above
the cigarette machine in a roadhouse
that has long vanished or which hangs on
by some little gas station and two motels
fifteen miles away from some more
populated place in New Hampshire.
You have to pull the knob and wiggle it
if you want your Parliaments to drop.
Think of a lot of stars over a parking lot
and no cars in the parking lot at all.
There are all these hunters crushed
with hunting hats and arms and rifles

all akimbo, some of them dressed
as Daniel Boone, and here is why:
this giant chicken came after them
at the bar, and so down she sat on them
like they were her nest, her little bald-
headed, crying-mouthed, squinting brood.
This bar does not even exist anymore,
but look at the stretched hands over
these keyboards, the cuffs on the hairy
wrists. They work at keyboards. They
have cuffs. They talk. They look dumb.

Free Variation on "Wildwood Flower"

All thoughts get dictated to us once
we go and neglect pale wildwood
flowers all year in our heads—meaning
forget about it, just do your job: be
your entire life, alcools, and twang,
a blues hangover, a pageant
that lasts us all through winter
surf-side, a strong man
with a bald head
who flexes his muscles
and practices his profile,
with a demon child there
scattering sandpiper flocks,
and the old circus emanates
and smiles over the late light
at a lady with a two-piece suit
and deep C-section bite,
sweet pitted thighs like a flute
for Rubens, and water rushes
in the wet sand trenches dug
for kid finger water to start
and then get overwhelmed,
and families wheel the wheelchair
grannies up the ramps or down
the slats to the hard
sand, and the water rolls
back up where a teenager
splinted up with crutches
has buried feet and pretzel legs
finding the "salve of souls"
as somebody once said

of another seaside Lourdes.
Everything gets ill, health
and sickness, old ocean wing
tumbled from the arcade
roof to the convention
hall across the boardwalk
caught in a red glow
of lights on a ride
and marsh sunset
and pizza neon, foreign
mid raven-black hair
waitress crooked teeth
in a pretty mouth, the benches
screened in and gull-
shat railings, where people eat
steak bombs, while we look around
at who will end up next to go
away from all of this sad joy
that also covers carapaces
right to the hinges, horns
and the complex eyes
of stranded horseshoes
with slipper shells,
with fat chance washing back.
I'm making a necklace here.

For the Friendship of Fanny and Ruth

An enormous spool of something, OXONITE
on the side of the truck, $15 to have a right leg cuff
sewn again to keep it from dragging
in the puddles on the sidewalks, the economy
and the fabric start to crack
the weekend you two read. What are the yellow
vests doing in your old hometown, Fanny?
Are they rightwing proles or just neo-fascists
in prole getup, swinging a noose
at the lampposts with underground electric
lines, a noose with cellular data threads.
Since this could be an archangel problem,
Ruth, you are the right person
to have in the studio armchair.
What is this bad feeling today? Not sure
it will pass years of yearning for a sense
of holiness in the world that is not
world's end as the tameness of being a dream
in owl's leaves, and tragic, testifying, translating
two sisters who survived the camps, and, ahh,
I understand now, a day late, a EURO short, ahh,
fears and sorrows and fear of the Lord, ahh,
no wonder we put one thing next to another
because there is a truck with a big black cable
and OXONITE on the side and also
on the wooden spool, and the sidewalks
puddling at our cuffs, and it all makes sense,
if this pause
is the pause
in the time gap
to think, to hear the warnings. But it gets hard

for me to hear when this hat made of electric
candle-shaped light bulbs rides
a plain kid walking into the room, door
to Michael's studio, through the open door,
and with a plate with what are not eggs,
and all these children of Swedish diplomats
and businesspeople and the Vikings gotten
to the Commonwealth of Somerville
for the adventurous and dangerous season.
Ruth, cat soul, be with Fanny. Ruth, be here, friend.

For Dion in Belmont

The Napoleons got theatrical.
The bakery surrounded me with cakes
years after when I got along
with an invisible transistor

and getting called Hey-Boom-Boom-Washington, nice hat, ah,
 walk on.
Dull bronze eggs of peppermint-striped string dispensers hung on
 chains
level with a modish clock built into the paneling above an egress.
I saw snowy egrets by the dump on the edge of Pelham Bay Park.
 The hunt.

And in a dark night the bread-only bakery was open and windowless,
its doorframe full of bare bulbs, no fluorescence, and the crust
would rivulet into floury cracks,

the gush that swells and dissolves
with traces of peppery dust, fresh.
In the morning, the girls had nail extensions
with glue-on rhinestones on them like spaceships.

Short Time

—for James Kealey

1.

Forget the piety and pious responses
because if you write an elegy long enough,
it becomes another way to say hello, somehow,
until you collapse on the couch in your clothes.

2.

The Chinese restaurant on the corner was called Nice Food.
For years it was like this. We never fought once.

We just stood there talking. And then one of us would fall over.
That was what life was like.

And she was all going around the room, waving her hands, maybe
conducting stuff. To me, she was like some Glinda the Good Witch.

And then if one of us fell over, the other was not even looking away,
just watching. Bright. Sometimes, you can catch somebody tumbling,

and sometimes you just don't. The both of us smelled like her wings
there, pleasant with its pure water with its pee, hard work, and flying.

3.

Army Brats—

John Floyd in a cold January day was hatless and pink-faced and wearing his glasses with thick lenses and fog on them. His down jacket or sometimes just a vest was hand-me-down from Ted, his ornithologist brother, and may have been hand-me-down before that. All the John Floyds were like that. I mean all the army brats were. Big family. Where is this place, in Virginia? Now that was moonlight walking and remembering the organization of books and their details and feelings.

4.

First Jim died. Then the cat died. Then another pal spends five weeks with some tubes in his nose, and he still lives. Famous people, on the other hand, give everybody such a ball when they die.

5.

Why I Am Not a Vegan—

Most cows *like* to be milked.
Some animals are really dull
as Canada geese
who nap, nip on the median.
The years go by too quickly
when I visit my aunt and uncle
for coffee, my silver-haired
aunt and uncle.

Sandwich time, we
all torture each other
around the kitchen table,
the mayo, the mustard,
the fathers and sons,
the moms, the cousins,
but the underhanded subtext
of meanness and competition
only flares out for a moment,
one note among many
notes flying and back
and forth while the orchestra
tunes up beneath the seats.

Look, my friend says, I'm in
heaven, I'm sorry

for your tears. Some of them
are for me, and I appreciate.
Thank you. That's love. But some
of them, let's face it, are
for you, so try not to be
stupid now and then go let
love lead to hatred. EAT
cheese. It's not a kidney.

6.

The early Romantics did not have such nice shoes. They were like flats, and if some wore boots, they were sort of pigeon deals. They would go walking out in the winter nights of torch-lit university towns, especially if the snow was blue, and then look at those cobblestones going down, or that hard icy curb between the curb and the cobblestones. These shoes have got to get with it, the future. This walking here will just about kill me if I don't really concentrate where I put my feet, o shit.

Big Family Poems

—for my sisters
& brother

1. *Wanted Poster*

In all the blab
and pork chop
and love
and hate,
we need solitude
and silence, too.

2. *Waiting for the Boston Women's March*

Bad dynamic. He thinks, young pelican, I feed you fish,
and you go out in the night with that big red hair.

He stands with his glass of wine in the dining room
trying to get as much of his ass as possible

over the heat register in the corner.

Midnight, every night, the guy in his hoodie
throws a spitty tennis ball to his German shepherd.

Bad translation. They kept reading it, "like watching
Kung Fu again," academic somehow, hardly flowing.

He thought he might go
to a conservative political rally

and wave a skewer
of uncooked SPAM above his head,

what else could go wrong?

For five days, they wore the same
brown corduroy pants.

Ridges were flattening out,
with supplicant creases

in a few odd places.

Mr. Urbano knocked at the tenant's door
on the ground floor. "Jiggle the handle."

Fig tree wrapped out back,
cut out in the pavement

before the fence.

Even though he was safe in 1978,
the late first baseman touched

the runner's knee with his glove,
laughing together, both of them,

in May, afternoon game.

The entire kitchen and sushi bar staff
napped in the dining room for an hour

between lunch and dinner hours.

Still in kitchen whites, she stood
on the giant river blocks casting

for big river carp
while a garbage barge pushed

in one direction and a coal train
rolled at her back.

Domingo sang while tipping
all manner of shells into an illegal hole

in the floor to float away with the tide,
the same tide that shook

the chandeliers' reflections.

The "dumpster guys" were very polite
about making the waiter, cook,

and dishwasher stay open
until three a.m., left a century note.

She goes on up the hill to see her
girlfriend, pounding it on up that hill

in her big winter coat
with fur all up around the hood,

hero of Telemark, badass tonight.

The dancer in a leather jacket
had gotten herself a crew cut that day,

and Victor was ready to recite poems
from *Twenty Love Poems and a Song of Despair.*

To him, the humid morning smells healthy
at the zoo, maybe straw,

maybe mung-bean noodles while they soak.

The sidewalk, all that wide expanse
along the black iron bars

of the Little Sisters of the Poor,
then bump bump bump, plenty

of ice on the sidewalk after that, then whomp.

Wearing socks, she toed the cold floor
register grate. That was how it was going

to be for the whole country.

After the show, he says he also raps
and almost jumped up there himself,

wearing construction boots from work
and a vest with a lot of practical pockets.

Midnight, waters running, the guy
in his hoodie throws a spitty tennis ball

to his German shepherd,
next to big piles of plowed snow.

It is a warm night in winter.
The young people under thirty

are all acting frisky as can be.

They found each other;
by winter's end, we all can turn

to stuffed dolls made of yarn.

Some lean rich people
have short-cropped grey hair

and play squash and run on treadmills
in finished or archaic basements,

by stony foundations, in damp earth.

"Good Lord, I've got the willies," Rimbaud thinks,
fingering a phantom crawl in his head. Lice.

The barbarians knew that the use
of jargon was an expression of shame

but used jargon by the curb, in the woods.

Being in love and being loved, she reached
for her love and thought, "Let me hold that one."

She lost a whole band of ideas, for a moment or more;
they were righteous, too, the first steps in a new land.

3. *Endurance of the Absurd*

One time two sisters,
nuns actually,
in an awful tennis joke
about God and cursing
not based on me
and my baby brother
like Shoney's Big Boy
were road-tripping
and smoking cigarettes,
and the one not driving
kept burping up Diet Coke,
and the brother driving
me got really freaked out
and grouchy, and said,
"Hey there, fuck, sewer breath,
with the decomposition
of household waste
and cleaning supplies
wrapped around the corner
by the Cambridge line
by the monument place
selling headstones, angels,
if I did not find
you remotely sympathetic
I would not locate
the salt of the sea
and breakdown
of aquatic plants
and all manner

of sea life on the waft
of the cargo tankers
into the harbor, nor
the silver grain silos
and panoramas
of livestock left to roam
north of the Red River
along past the mountains
time present/time past
of turnpikes into corn,
jet fuel in the accordion
to the US Air flight
in the rain to the cloud
belt, the cloud belt
in its sulfurous steel mill
early morning drizzle
reaching the houses
on the hilltops by
desert, prairie, stone
by the river, coffee
and bacon, the locust
trees, the cherry
tomato plant with two
cherry tomatoes,
the first two of the year,
and that old lady, our
great-aunt, gone down
to the bushes to find
her morning newspaper
with this sort of stuff."

"Damn.
Open the window,"
said Sister Mary Elephant.

4. What I Believe Again at Walden Pond Now

"in my heart Walt Whitman's mind"
—Gerard Manley Hopkins

A girl micro-pens hand-colored cartoon razor panels into her diary,
fine-hands dialogue bubbles and her prose narration while some guys

blast Donald Vincent's new album, his flow from a boom box
far away enough to sound only nearby coastal undulations.

The highways turn the color of nicotine stains, the lateral roads
and the overpass streets, rustier by bridges festooned with flags

all over again, summer, roads too narrow for trucks, come to the pond,
even some long-fingered bossa nova guitar chords, a friendship picnic,

up around the lifeguard-free bend, two old guys in ball caps, such
 old shits,
with outboard tilted up, and boat high in water, lines out, golf
 shirts, can

feel my own shorts crawling, about the same age, about, as a
 Chinese couple
emerged from spontaneous dip in water, the lady soaked

and laughing in a dress, maybe come from a Baptist church, feeling
renewed, amused, screw rules, go this way, his slacks knotted to shorts.

All smart people come here. I believe a lady who ladles out bean soup
from her zinc pot here, kinder, thriftier, work-smart, family-love people

with enemies. I see a guy read *What Maisie Knew.* I see a lady with
 moles
read an academic journal with small print, graphs and two columns
 per page.

I see a couple perform retina scan and thigh exchange in supple
 leopard-print
trunks though I can't tell whose ass went with whose arms, pure circus.

I see some rashes and dry skin and peppermint-pattern belly-meat
 all-gender
thigh because we have to sit in so many clammy places, like
 Somerville buses.

It is a good place for the nerdy to swing far out here, the law
 students speaking
with their transitions and paragraphs, and the goof who interrupts
 the flow

of mutual discourse to say, "wow wow wow," as his partner steps
 from her dress
toward the water, but hey, man, you get too shady in my poem,
 come on.

We all think about bacteria, microscopic life, the large and the small,
as the pine-cone pollen swirls its golden, starry shapes on the waters.

And the pond will be closed next week on account of algae from piss.
I believe everybody here, wicked pissers, the babies especially.

Notes

"A Drumlin Mansion in Ipswich"—
from Article I, Section 9, the Constitution of the United States,
No Title of Nobility shall be granted by the United States ...

"The Armies of Being Here to Eternity"—
Here is a song by Blind Boy Fuller: "Get Your Yas Yas Out."

"Problems with the Early Times Poetry"—
Here is a song by the Talking Heads: "Big Country."

"Odd Facts of Cape Cod in Judgment Time"—
The Dugan fragment is from "The Significance of Corn in American History."

"For the Friendship of Fanny and Ruth"—
This poem celebrates a reading Fanny Howe and Ruth Lepson gave together at Michael Franco's studio in Somerville, Massachusetts.

"Big Family Poems"—
J. V. Cunningham's drive from west to east goes "by desert, prairie and this stonewall road" in "To What Strangers, What Welcome" (1963). Sister Mary Elephant is the nun who yells, "Class, class, SHUT UP" in the Cheech and Chong routine "Sister Mary Elephant" (*Big Bambu* album, 1972; also a single). The actual quote from Hopkins is "I always knew in my heart Walt Whitman's mind to be more like my own than any other man's living. As he is a very great scoundrel, this is not a pleasant confession."

ACKNOWLEDGMENTS

Thank you to the editors of the following poems where poems from *Barbarian Seasons* first appeared:

Agni: "For Goya's Public Ice Skaters of Spain"

Arts & Letters: "Free Variation on 'Wildwood Flower'"

Boog City: "By the Grave of Robert Creeley," "For the Friendship of Fanny and Ruth"

Charles River Journal: "Free Variation on Yehuda Amichai," "First Spring Day on a Basketball Court"

Fence: "Thinking about the Bronx"

Great River Review: "A Drumlin Mansion in Ipswich," "Hairy Leg Poem," "Moony Nights," "Concord River and Walden Pond," and "On Jim Kealey's Ashes Launched with a Potato Gun"

On the Seawall: "Odd Facts of Cape Cod in Judgment Time"

Plume: "Black Mountain Music," "Riding the Metro-North New Haven Line"

Salamander: "Is Writing Helpful?"

South Carolina Review: "At Fenway Park"

sPoke: "The Armies of Being Here to Eternity," "Poetry of Friendship," "Short Time," and "Big Family Poems"

storySouth: "Lines for Pope Francis in Cuba"

Thank you, Marc Vincenz, David Rivard, friends and students from the MFA Writing Program at the University of New Hampshire, Jessica Bozek, Stanley Moss, Julia Story, Ron Slate, John Mulrooney, Ruth Lepson, Ben Mazer, Kevin Gallagher, Tanya Larkin, Stephanie Burt, Donald Vincent, Donald Revell, Ruth Lepson, Natalie Reitano, Steve Almond, John Sebesta, Zev Levinson, and especially, Sabrina Blair.

ABOUT THE AUTHOR

DAVID BLAIR's first book of poetry *Ascension Days* was chosen by Thomas Lux for the 2007 Del Sol Poetry Prize. He is also the author of *Friends with Dogs* (Sheep Meadow Press), *Arsonville* (New Issues Poetry & Prose), two books that appeared in 2016. MadHat Press also published Blair's first collection of essays, *Walk Around: Essays on Poetry and Place*. He has recently taught creative writing in the MFA Writing Program at the University of New Hampshire and in the online masters degree program at Southern New Hampshire University.

davidblairpoetry.com